HERDING CATS

A "Sarah's Scribbles" collection

Sarah Andersen

T0418608

Andrews McMeel
PUBLISHING®

HERDING CATS:

"A futile attempt to control that which is inherently uncontrollable."

TAKING CARE OF...

My pets

My friends

My significant other

Myself

Contrary to popular belief, being introverted is not about your ability to socialize.

It's about what you do after.

MY ABILITIES

BEFORE AND AFTER FAME
ACTORS:

MUSICIANS:

ARTISTS:

LATER THAT WEEK

MOST PEOPLE

ME

RETAIL THERAPY

Before: sad.

After: sad but in a fabulous outfit.

SPENDING A DAY OFF-LINE 2010:

TODAY:

PINKY TOE SMACK

WINTER

SPRING

SUMMER

FALL

EMOTIONAL BONDS

HOW TO PUT A SHIRT BACK WHEN SHOPPING

MY INTERNAL MONOLOGUE

HAPPY
MUSIC

MOODY
MUSIC

DEVASTATINGLY
SAD, TRAGIC,
SOUL-CRUSHING
MUSIC

Me constantly stressed by the news

Me kind of believing the world is ending

Me feeling powerless and terrified

Me feeling devastated always, but also it's fall

#1 SPOOKY B*TCH

JINGLE
PAT PAT
PAT

CREEEAAKK...

!!!!

LOGICAL PATH

OVERTHINKER'S PATH

8:00 AM
MORNING PERSON:

NIGHT PERSON:

POSTURE

PRE-2016

POST-2016

CHECKING THE NEWS MOST OF MY LIFE:

NOW:

WHEN I DO HOUSEWORK

WHEN MEN DO HOUSEWORK

ME

ME, IF MY SECRET
INNER STRENGTH
WAS PHYSICAL

VENTING

SOCIETAL MYTH

Artist + sadness

Great art

THE REALITY

Artist + sadness

Uninspired, sad artist

TRUTH

Content, happy artist

Artist happily working

CAT SHAPES

Round

Long

Curve

Loaf

DOG SHAPES

Dog

Baby cat

Baby dog

Baby

FINALS SEASON

COMING HOME

.002 SECONDS
AFTER COMING HOME

DRAG

WHAP

MMRRRRRRRR

? She does this sometimes when she's sad.

IN THE FUTURE

GREETING A DOG

ME + ME: A GREAT TIME!

Talking and singing to myself

BLAH BLAH BLAH

Arguing with myself

Fashion show with myself

Dancing with myself

CHILD

ADULT

MAKING STUFF
IN THE MODERN ERA:

A Guide for the Young Creative

PART ONE:
WHAT'S HAPPENING?

For artists, writers, and creatives of all kinds, the Internet has been a game changer. It has offered us tools, tutorials, references, and an easily accessible public gallery where we can post and discuss our work. With new possibilities and projects opening up every day, artists can now support themselves exclusively online.

I always knew that I wanted to be an artist, and having access to the Internet at a young age gave me the stubborn belief that it was absolutely possible. I spent a lot of time on various art websites and paint chat rooms looking at work I liked and practicing my own budding craft. I was so confident that I could become a professional artist that it was impossible to convince me otherwise. My parents and teachers, of course, didn't necessarily have the same idyllic confidence.

But the Internet is changing. Or rather, it's starting to show its true colors. In those paint chat rooms I used to frequent, I felt like I was finding a party that was exactly where I wanted to be with exactly the right people.

In the end, with a lot of (hesitant) support and luck, I did become a working artist. It's a privileged position to be in, but it's one that I want to be accessible to everyone. Which brings me back to the Internet. In theory, any scrappy young kid with a tablet and a Wi-Fi connection could pick up a pen and become the next big thing. This is what was and still is great about the Internet: With the right grit, everyone can carve out a place for themselves.

There's just one problem—the party's on fire now.

Having some degree of Internet presence has now become commonplace for most people. And it turns out, when you give people endless access to a shroud of anonymity and a soapbox, the results might just be disastrous. Whereas users congregated in small pockets before, social media has enabled the rise of mass movements that use trolling as a deflection tool for "doing the most damage I can do and then saying it was just a joke." This culture no longer hides in anonymous corners but exists in the mainstream and is unavoidable.

In light of all of this, my perception has changed.

And, of course, my emotional response to the Internet has changed as well.

Despite my own personal luck and illusions, the Internet was never, in truth, actually a nice place. Harassment campaigns and other atrocities have always been common and accepted, with marginalized folks testifying that the danger has always been there. We just weren't listening.

The harassment in particular has been an ugly smudge online, but in my opinion, the level to which we have all accepted it as normal is bizarre and inhumane. Undoubtedly, we have lost empathy in front of our screens.

Is it hard for me to understand that people are capable of cruelty? Well, no. But I still grapple with some of the sheer absurdity. I often envision a scenario in which I go back to the past and try to convince myself that this is all real.

I've been thinking a lot about that younger self lately. I wonder if she would have had the gall to post her work online. Growing up, I had no inherent fear of online culture. Now, when I give talks about comics, kids and teenagers constantly ask me this question:

"I'm afraid to post my work. What should I do?"

And truly, with a heavy heart, it feels sort of like they are saying, "Well, I make art, but I'm afraid to expose it to the fire party over there."

And I can't blame them.

But my answer is always the same.

Despite accepting the notion that the Internet is turning into a place that simply isn't conducive to the sensitive nature of most artists, I refuse to believe that it is a permanent state. Change is possible, but more importantly, no one should be stopping the many creative kids who have things to say and pictures to paint.

It's a tough world, but it's possible to navigate. So, here's my advice from me to you on how to survive both the Internet and your life as a creative.

PART TWO:
ARTIST SURVIVAL

(By the way, it's not always a flaming hellfire.
Just sometimes.)

Sometimes the burning is... less burning!

1. GROWING PAINS ARE COMMON AND OKAY.

Before you survive the Internet, you first must survive yourself. There are some self-inflicted thought patterns that halt artists before they ever even post online. Growth as an artist is a strange thing. What this often means is that as you get better and your eye improves, your earlier life's work starts to look worse.

This cycle is completely natural and normal. It repeats every few years. But don't forget: It means you are getting better!

THE ARTIST'S CYCLE

Furthermore, people can often succumb to myths about art that are simply untrue. For instance, the nature of creativity is somewhat elusive. Sometimes people go through creative blocks, and they believe that their artistic spirit will never return.

In my opinion, artists never really truly "peak"; their work just continues changing form. I don't buy the idea that artists make a magnum opus, and then everything goes downhill from there. People are not one-hit wonders. As long as you keep working, creativity is an essence of who you are, and it never vanishes. Remember the art cycle: Every time you make a masterpiece, in a few years, you'll have made a new one.

Of course, everyone has lifelong standouts.

ME AT THE PEARLY GATES

2. UNDERSTANDING CRITICISM AND HARASSMENT.

Criticism is necessary to growth. Ideally, it's presented to you productively, with kindness, and at an appropriate time. And even when it's positive feedback, artists have a tendency to mentally twist the words.

WHAT THEY SAID

WHAT YOU HEARD

But, the truth is, criticism isn't always presented kindly.

It's not fun, but feedback is supposed to help you. Critique is important. You can view criticisms as tools toward your own progress. And when you yourself as an artist give critique, use your past experiences to help the other person hear what they need to without totally destroying their soul.

Remember to treat not just other artists but yourself with this same empathy. I often find that the harshest criticisms come from one particular person.

If something is too harsh to say to someone else, maybe make sure you aren't constantly saying that thing to yourself.

It's also important to remember that while navigating the online world, people will often cross the line. Bullying and harassment, like personal attacks, people telling you they hate you, etc., are not criticism. They don't help you improve no matter what way you look at them. What do you do with feedback like this?

3. IT'S OKAY TO HAVE FEELINGS.

Everyone gets criticized at some point. *A lot* of people get harassed at some point. While even the harshest criticism is something you can eventually adjust to, harassment should never be normal. It's okay to have a strong emotional response if this happens to you.

You could (and probably should) maintain at least the illusion of a cool exterior online, but you should also let yourself be human. When you feel hurt, let yourself feel hurt. Let yourself process and recover. And then go back to being the ice-cold superhuman that you are.

You are also capable of surviving pretty much anything. Think back to all the times you swore you couldn't get through something. If you're here, then you did get through it.

4. GO OUTSIDE; THE OPTION IS THERE.

I know, I roll my eyes at this one too. One of my biggest pet peeves is being told that we are a phone-obsessed generation and that, in order to solve all of our problems, we just need to go outside. Another thing I can't stand is people telling others who are being harassed online to simply turn the computer off.

What they have failed to understand is that the times have shifted. "The Internet" and "real life" are no longer two distinct concepts. Instead, they have merged, and we now live in a world that blends the two almost seamlessly.

But escapes are still possible and healthy, if somewhat temporary. Anyone, not just creatives, can benefit from breaks. Sometimes you just don't need to hear all the chatter. Sometimes the only person you want to listen to in a particular day is yourself.

5. DON'T GIVE UP.

Here's where I heavily borrow from your typical never-give-up anime script.

People like you. People like your stuff. Truth is, when you're feeling down, there's a good chance there was just one negative comment in a sea of positive ones. And there is ALWAYS. THAT. GUY.

Don't surrender to that guy. Don't give up. It's cheesy, but it's true. We need more work. We need your opinions in your work. When you have something to say, I'd like to hear it.

Creativity is not only worth it but is necessary in these times. Artists and writers have the unique ability of looking at the world and reinterpreting it in their own way, and this perspective is one I would sorely miss if a young creative chose not to show their work. And for the sake of my own sanity, I much prefer spending my time looking at the works of new, growing artists than the fire party that the Internet has become. Sort of like . . . a little blossom of hope in an apocalyptic landscape.

And don't forget an even simpler aspect: Making work is actually fun. It's healthy and rewarding, and for many creative people, it's central to who they are as a person.

And that person deserves to have a spot where their work can be seen and admired. So please, if you are intimidated, I hope that you still choose to participate. I can't force you, but I can nudge you.

In a world where every single person—good or bad—has a voice, I hope you pick up your pen and use yours.

In the meantime, I'm practicing deep breathing.

Go make stuff.

HERDING
CATS

Andrews McMeel Publishing
a division of Andrews McMeel Universal
1130 Walnut Street, Kansas City, Missouri 64106

www.andrewsmcmeel.com

22 23 24 25 26 SDB 10 9 8 7 6 5

ISBN: 978-1-4494-8978-6

Library of Congress Control Number: 2017950651

Editor: Dorothy O'Brien
Art Director and Designer: Diane Marsh
Production Editor: Amy Strassner
Production Manager: Tamara Haus